To:

From:

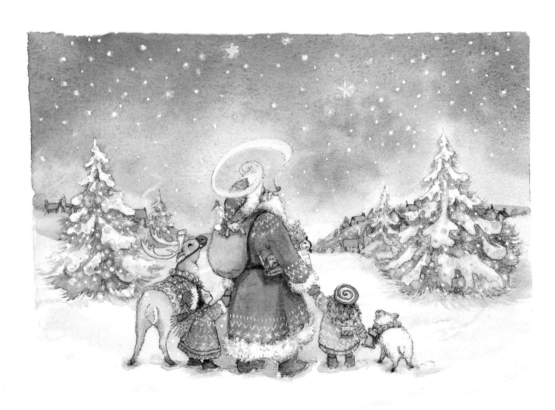

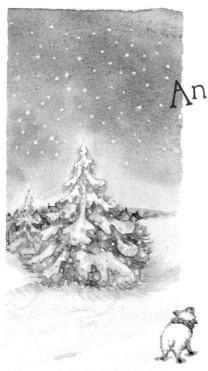

And Then in a Twinkling

Illustrated by Becky Kelly

Written by Patrick Regan

**Andrews McMeel
Publishing**

Kansas City

www.andrewsmcmeel.com

www.beckykelly.com

02 03 04 05 06 EPB 10 9 8 7 6 5 4 3 2 1

ISBN: 0-7407-2644-7

Illustrations by Becky Kelly
Design by Stephanie R. Farley and Becky Kanning
Edited by Jean Lowe
Production by Elizabeth Nuelle

Thanks to the One
Who makes the Stars Twinkle

My heartfelt thanks to my Editor, Jean Lowe
A truly Creative Visionary

And to Patrick Regan
For his Inspirational Writing

Special Thanks to the team that put it all together!

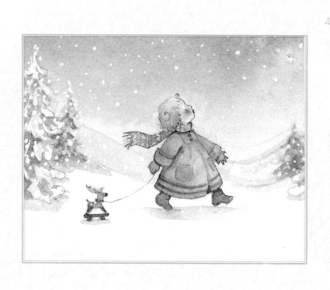

And Then in
a Twinkling

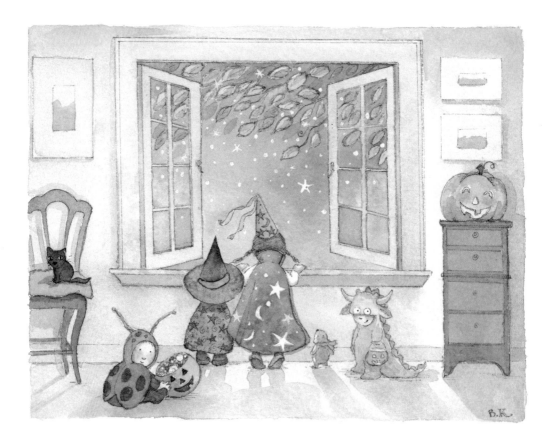

It seems only days
since kids yelled with delight

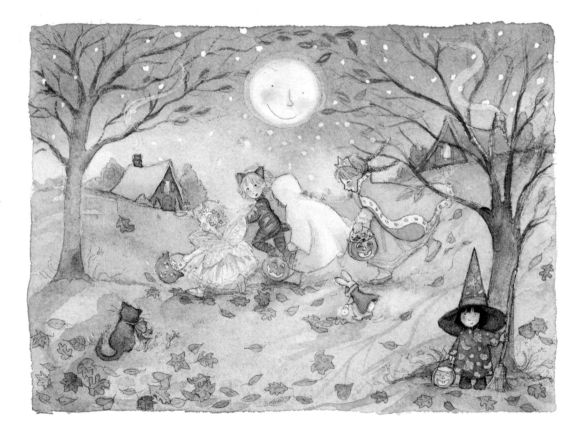

on a door-to-door journey
through the autumn twilight.

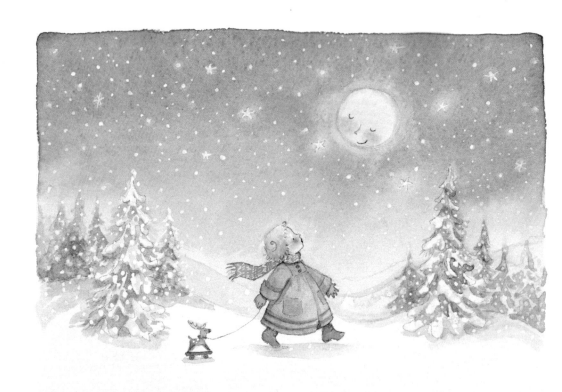

And then, in a twinkling . . .
December is here—

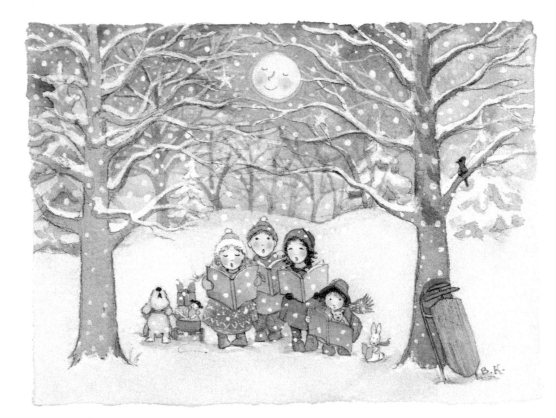

There's frost on the pumpkin;
old songs fill the air.

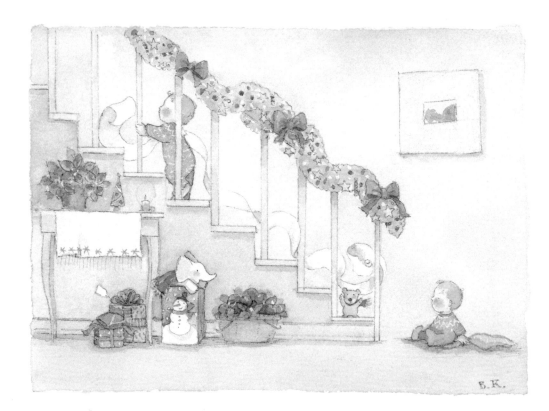

So haul out the holly . . .
and deck all the halls . . .

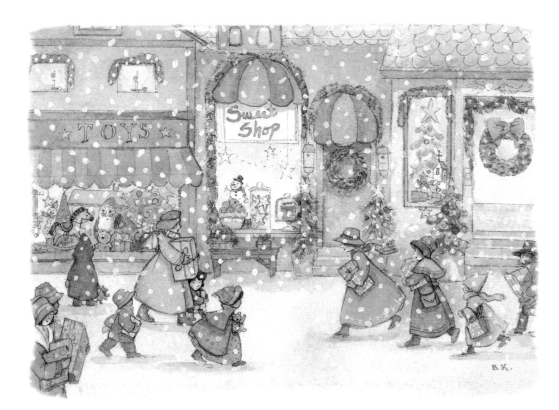

and start the list-making . . .
and visit the malls.

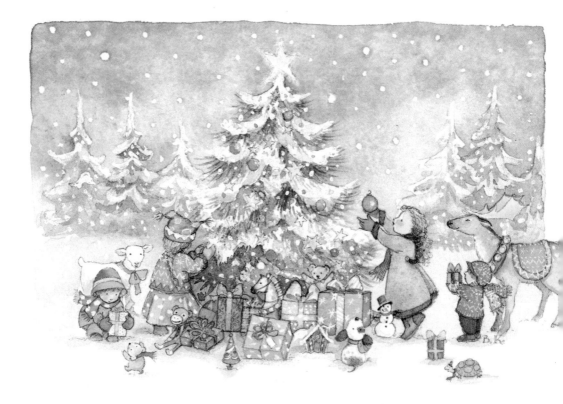

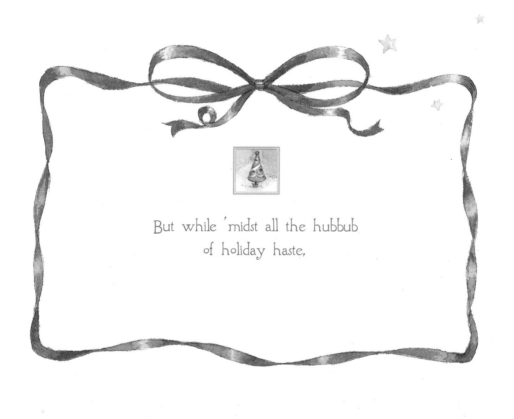

But while 'midst all the hubbub
of holiday haste,

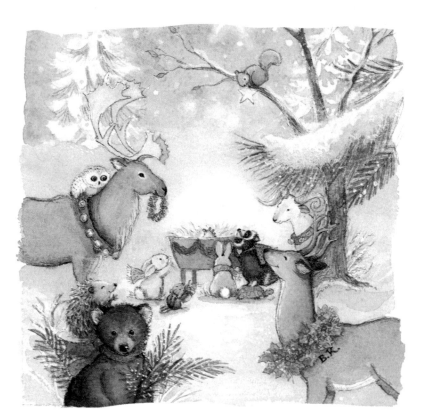

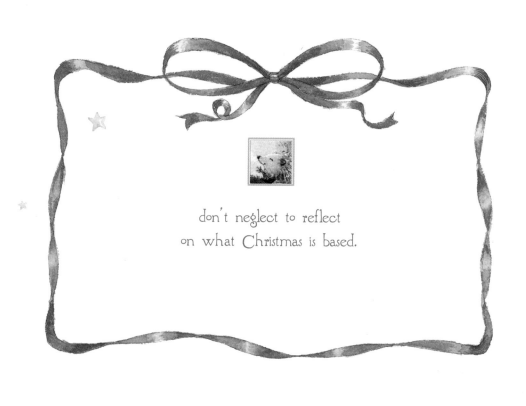

don't neglect to reflect
on what Christmas is based.

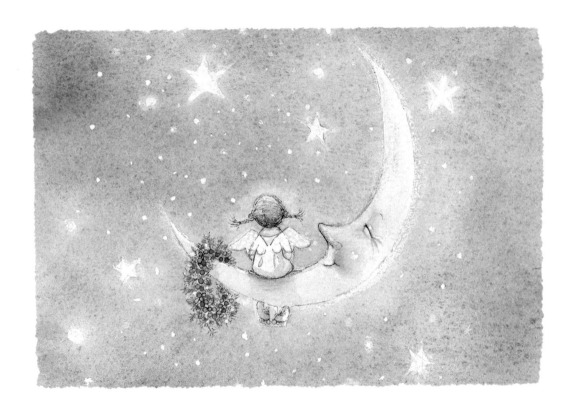

And then, in a twinkling . . .
the magic comes back.

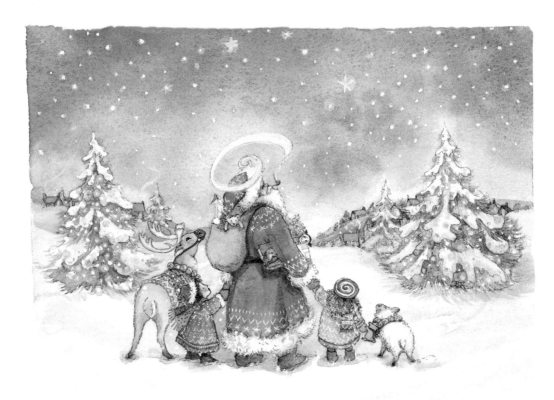

The true meaning of Christmas
can't be purchased or packed.

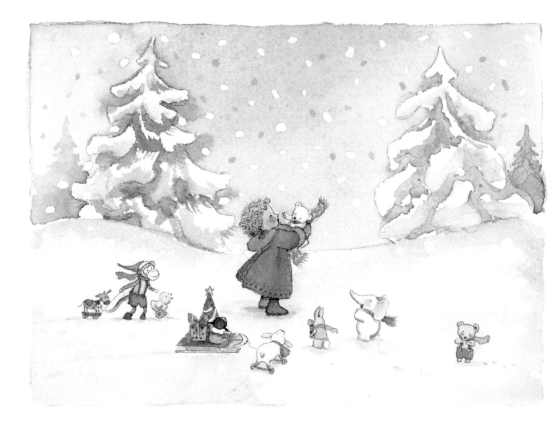

For Christmas brings goodness,
redemption and light

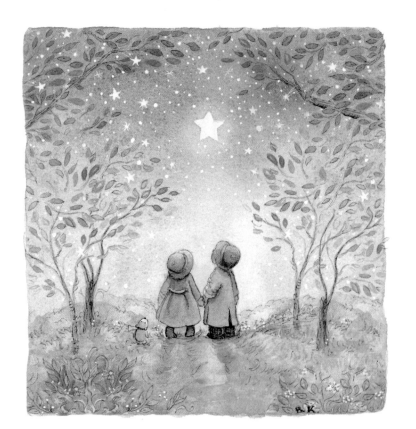

and helps reconnect us
to all that is right.

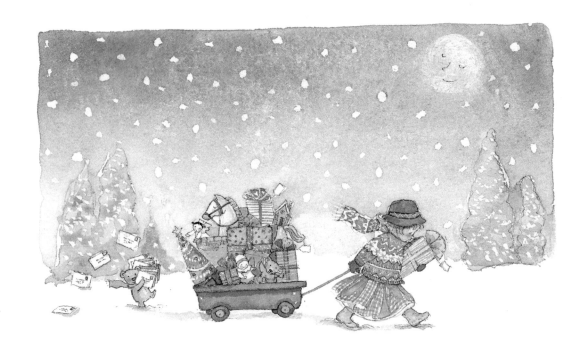

So don't miss the wonder
while lost in to-dos,

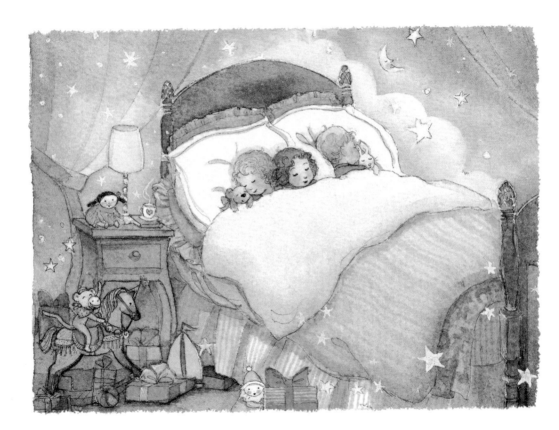

because, in a twinkling . . .
this day will be through.

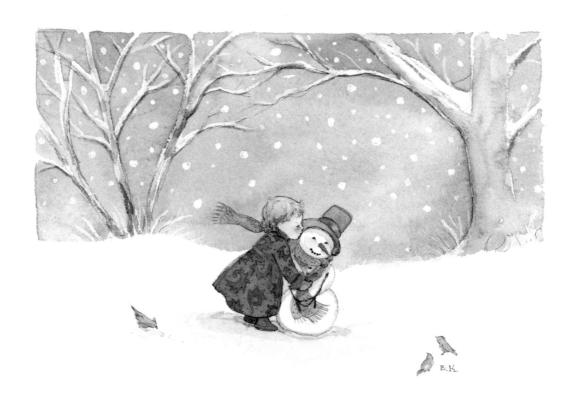

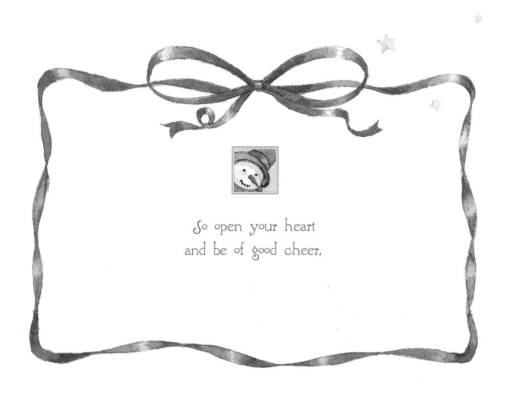

So open your heart
and be of good cheer,

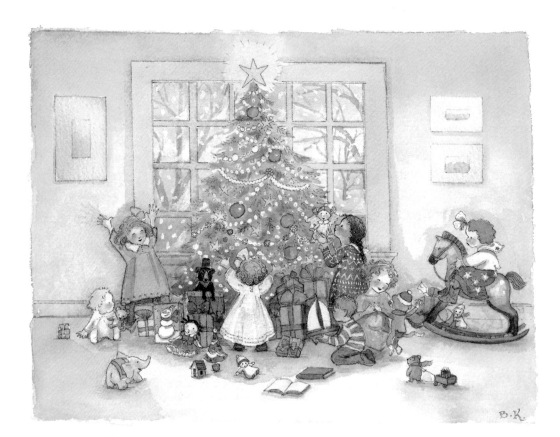

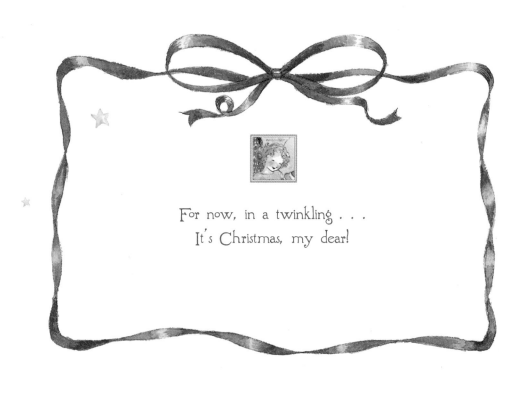

For now, in a twinkling . . .
It's Christmas, my dear!

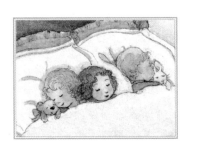